Wild Fl
Watercolour

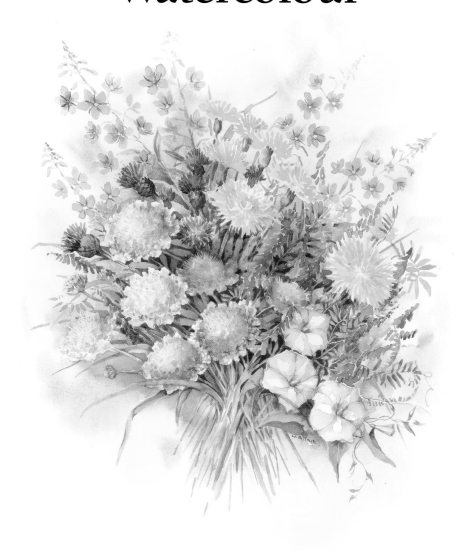

W. Argie

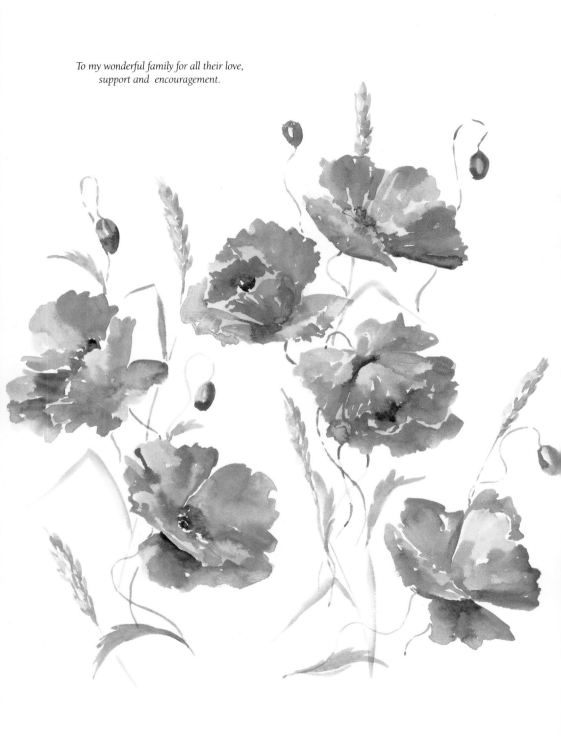

To my wonderful family for all their love, support and encouragement.

Wild Flowers in Watercolour

WENDY TAIT

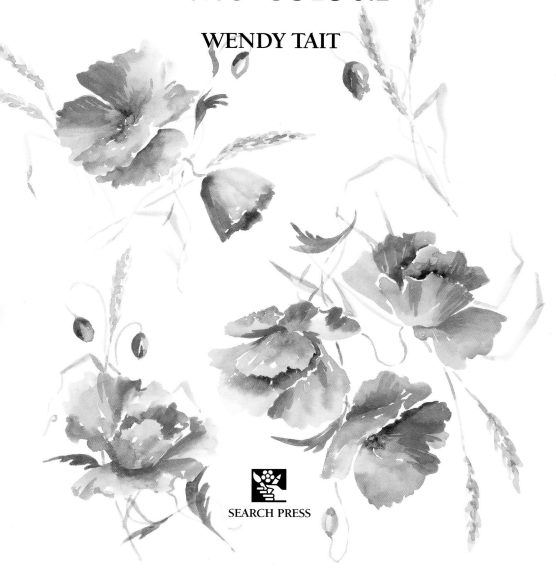

SEARCH PRESS

This edition first published 2014

Search Press Limited
Wellwood, North Farm Road,
Tunbridge Wells, Kent TN2 3DR

Originally published in Great Britain 2003

ISBN: 978 1 84448 982 4

The publishers and author can accept no responsibility for any
consequences arising from the information, advice or instructions
given in this publication.

The publishers and author would like to thank Winsor & Newton for
supplying many of the materials used in this book.

Suppliers
If you have difficulty in obtaining any of the materials and equipment
mentioned in this book, then please visit the Search Press website:
www.searchpress.com

> **Publisher's note**
>
> All the step-by-step photographs in this book feature the
> author, Wendy Tait, demonstrating how to paint flowers in
> watercolour. No models have been used.

Printed in Malaysia

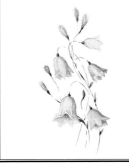

*My thanks to Ally and Roz at
Search Press for all their help
and technical guidance, and to
Betty at the farm for allowing me
to pick the flowers.*

Cover Summer Days
*I asked permission at a local farm, then
picked this bucketful of flowers from
their fields.*

**Page 1 Scabious, Vetch and Rosebay
Willowherb**
*All these flowers grew within twenty
yards of each other in a country lane
near my home. When you really look, it
is amazing the variety you find.*

Page 2/3 Poppies and Corn
*I really enjoyed the feeling of painting
these poppies very loosely, letting the
colours run together without worrying
too much about detail or accuracy.
I used Winsor lemon, gold, Winsor
orange and quinacridone magenta for
the petals, dropping in ultramarine with
a touch of Payne's grey and my 'green
mix' for the centres.*

Page 5 Wild flower bunch
*Lots of my favourites were brought
together in this bunch. The blues
provide a perfect foil for the gold and
white. The colours used were a touch
of Winsor violet, Winsor lemon, cobalt
blue, quinacridone gold, and my 'green
mix' of Winsor lemon and Payne's grey.*

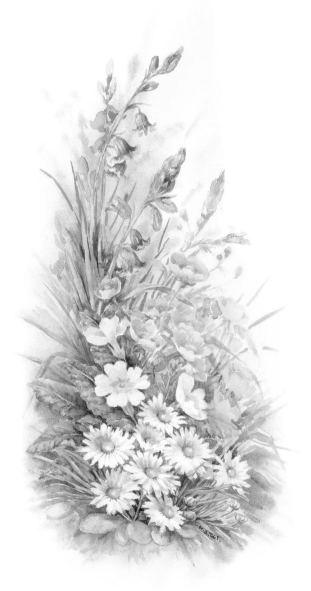

Contents

Introduction

Painting wild flowers can be quite a challenge, for many reasons. Many of them are very small and delicate, which means that they are more 'fiddly' to paint than cultivated flowers. This means that they need closer study before you begin to paint, and that the paintings take longer to complete. It does not mean over painting, however. Quite the reverse! Wild flowers need a subtle, delicate touch to complement their fragile beauty.

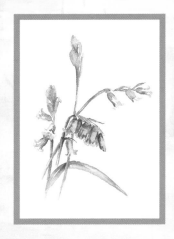

Another challenge faced in trying to capture wild flowers is that, ideally, they should be painted *in situ*, especially if they are not the common varieties like daisies or buttercups. Picking wild flowers means that there will be fewer seeds to be spread, and fewer flowers to be enjoyed by others the following year. In many areas, picking wild flowers is actually illegal. Luckily, it is now possible to buy wild flower seeds and plants to bring into our own gardens, providing easily-accessible subjects for painting and helping to ensure that they are not lost to future generations. Many species are already losing the battle with modern life and methods of farming which threaten our hedgerows.

Painting out of doors also means that you have to contend with the elements, which can lead to awkward situations. It is often too hot, cold, windy, sunny or rainy, but it is all part of suffering for your art, I believe!

Research will improve your painting. Study carefully the way your flower grows, the way it is attached to its stem and the way the leaves grow. Know whether its habit is to ramble, to stand straight or to form a bush. If you are picking the flower to take indoors, look around you first. Look at the sky: is it a misty or a sunny day? Do you want this mood in your painting? Try to feel the atmosphere of the area. If you were sitting outside, all of these elements would affect the way you painted. I feel that it is more important to capture the feeling of the

flowers and their environment; the colours, the wind, the season, than to produce an accurate botanical study.

Despite all the potential problems, I still love to paint these fleeting treasures. I defy anyone exploring the countryside not to experience an enormous uplifting of the spirits at the sight of a bank of primroses, a bluebell wood, a swathe of poppies or a bush of wild roses in full bloom. These are the times when I am so glad that I am a painter. I sometimes wish I was a poet too.

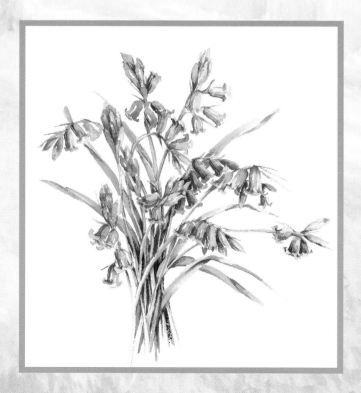

Materials

These are my basic materials, which have evolved over the years as I have painted. Everyone's taste varies, and it is a good idea to experiment with different materials until you find the ones that suit you best.

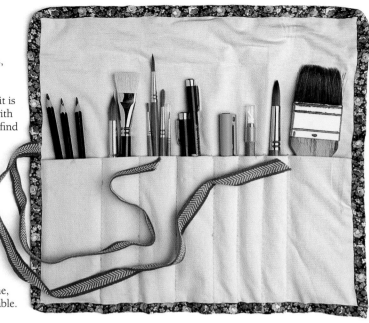

Fabric roll

I like to travel light when I am painting, and this fabric roll with ribbon ties is perfect for keeping my brushes and pens together. My mother made me this one, but similar holders are available.

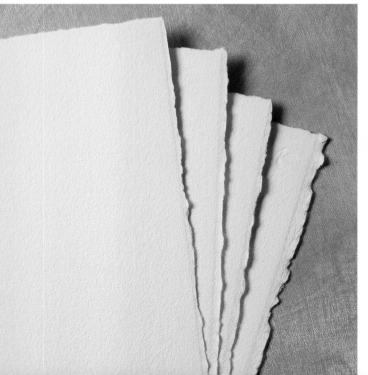

Paper

When taping paper to a board instead of stretching it, tape along the top edge only. This gives the paper room to expand when it is wet and contract as it dries. If you tape all the way round, the 'cockles' will have nowhere to go as the paper dries, leaving your washes uneven. If you use paper that has not been stretched it must be at least 140lbs (300gsm) in weight. I often use a block, as it provides a good, tight surface which is ready when you are.

A range of different white papers, all with a Not surface and a weight of at least 300 gsm (140lb).

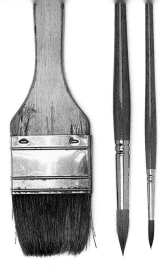

Paints

I find that it is better to buy a few artists' quality paints than a lot of cheaper ones. They last a long time and give better results, so they are better value in the long run. The colours I use are mostly transparent, rather than the earth colours that are used by landscape painters.

Masking fluid

I do not use masking fluid very often, but it can occasionally be useful. I have dealt with its use in more detail on page 28.

Shaper tool

I use a small rubber shaper tool (not shown) to apply masking fluid to a painting, as it can ruin your brushes.

Brushes

Make sure your brush goes to a good point. I use Nos. 12 and 6 brushes, plus a large flat 'hake' brush for applying water. For small detail, I use Nos. 1 and 2. Another 'must have' is a large mixing area, which can be a palette or simply a white plate.

Palette

I use a large white plastic palette with several deep wells to take larger washes, plus plenty of smaller mixing wells.

Colours

Over the years, I have listened to friends and students as we are painting together. It is wise to keep an open mind about materials and equipment; often, you can be introduced to something new and exciting. I love getting together with painting people and swapping ideas. Someone else's experiment with colour can be extremely refreshing, and can set you off in a new direction. A little of what they are using, alongside your own colours, can sometimes add an extra dimension to your painting.

I have used a basic 'green mix' of Winsor lemon and Payne's grey for many years, but nowadays I will often add a little indigo. To produce a warm, dark green, a mix of indigo and quinacridone gold is very good.

I have recently cut out raw sienna and new gamboge, as I find that I can mix beautiful yellows with Winsor lemon, gold and a touch of orange. Scarlet lake and ultramarine violet have also been banished from my palette. I find I can easily mix all the reds, pinks and violets I need with what I have left. I have, however, added ultramarine blue, which I find gives me a warmer, more intense blue.

My palette

Cobalt blue deep
Ultramarine blue
Winsor violet
Brown madder
Winsor orange
Quinacridone magenta
Quinacridone gold
Permanent rose
Payne's grey
Winsor lemon
Indigo

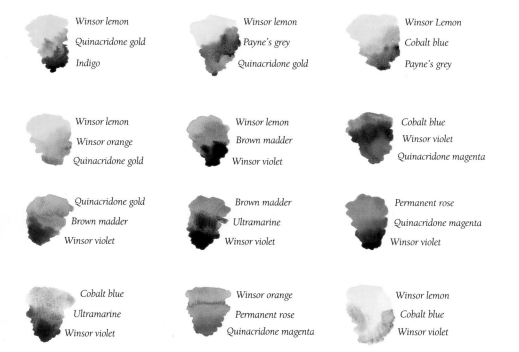

Winsor lemon
Quinacridone gold
Indigo

Winsor lemon
Payne's grey
Quinacridone gold

Winsor Lemon
Cobalt blue
Payne's grey

Winsor lemon
Winsor orange
Quinacridone gold

Winsor lemon
Brown madder
Winsor violet

Cobalt blue
Winsor violet
Quinacridone magenta

Quinacridone gold
Brown madder
Winsor violet

Brown madder
Ultramarine
Winsor violet

Permanent rose
Quinacridone magenta
Winsor violet

Cobalt blue
Ultramarine
Winsor violet

Winsor orange
Permanent rose
Quinacridone magenta

Winsor lemon
Cobalt blue
Winsor violet

Planning your painting

This is the most important stage. Whether or not you begin by using a little pencil — I prefer not to — make sure you allow plenty of thinking time. This is something you learn with experience. The beginner will often be desperate to make a start, and will jump in without thinking, or will be panic-stricken at the sight of fresh white paper and lose concentration. The answer is to study and plan out your composition in your head, as I do. If necessary, make a small 'doodle' of your idea on a piece of scrap paper.

Study the flowers well before you begin. Choose one flower, or a group that you like particularly, and begin to build your painting from there. Your main group of flowers, or focal point, should be larger than those surrounding them, and should usually be positioned fairly low on the paper. As you complete your painting, your composition can always 'grow' outwards from this point. Half-close your eyes when looking at the subject, so that the details disappear. Think of your flowers as light or dark shapes, and try not to make things too complicated.

I sometimes think that when I encourage them to dispense with a pencil, I am making it very hard for my students. Those who are brave enough to try must have an idea of what they are aiming for, and I know it may sometimes appear, wrongly, that I have no plan. A common mistake, when starting a wet-in-wet background, is to drop in colours haphazardly. I have a clear picture in my mind of where the colours are going to go before I begin.

I often like to make my main flowers the lightest in tone, so that contrasting darks can be slipped behind them in the final stages to make them stand out.

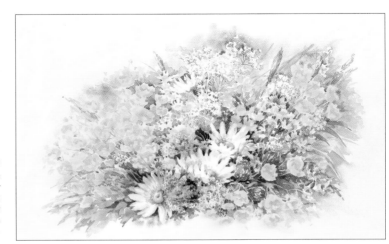

Summer Meadows

Negative painting behind the white daisies and clover shows the focal point in this painting. The flowers that are further away are far softer in colour and tone.

Composition

When planning a composition, I use my imaginary dotted lines (see below), and make sure that my focal point is at the approximate point where these lines cross. This is not imperative, but it often provides a guide to good composition. A successful painting has a detailed focal point, with everything else taking second place. Sometimes you will want to emphasise one flower, or a group of flower heads, and the flowers in the background should be misty and diffused. Look at your subject, pick out what you most like about it, and make this your focal point.

In a good composition, the lines of the main flowers can be echoed in the background flowers, which helps to carry the eye through the painting. It is also a good idea to restrict the number of colours used: when many brightly-coloured flowers vie for attention it can spoil the overall effect. Ask yourself questions all the time: 'What do I like about this subject?'; 'Do I really want to paint all I see?'; 'Is there a particular flower that attracts me most?'; 'Which viewpoint do I prefer?'

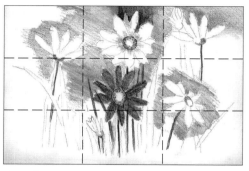

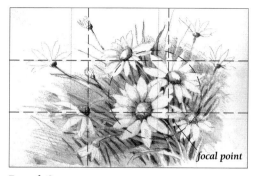

focal point

Example 1

This composition is not ideal. The flowers are too central and form a dividing line. The dark flower does not work against the background grasses: whatever its colour, it would have collected some light which would cause a shadow behind it.

Example 2

This sketch works far better, because the flowers are grouped off-centre and the largest is the lowest. The background grasses are darker, which has the effect of highlighting the flowers.

Troubleshooting

These points may help to solve some common problems:

Q How do I find my focal point?

Try starting with the flower, or group of flowers, at the intersection of your imaginary lines.

Q Why are my flowers too near the top of my paper?

Always begin the painting towards the bottom of the paper with the largest flower and work outwards.

Q Why do my stems and leaves look too dark?

Think of stems and leaves in negative. They are round, and collect light. Paint the darks around them for a more natural effect.

Q How do I prevent a 'halo' effect round my flowers?

Take the water far beyond where you want colour, often right to the edge of the paper. Drop in colour behind the flower, tipping the paper so the colour disperses, leaving no hard edge.

Foxgloves

I saw these foxgloves growing by a hedge, and moved the daisies much nearer to achieve a good composition. Note how the eye is drawn to the daisies and travels up the curve of the foxgloves. This is because the darkest darks, behind the lightest lights of the daisies, act as a focal point. Colours used were Winsor lemon, Winsor violet, quinacridone magenta, cobalt blue and a green mix made from Winsor lemon and Payne's grey. I used masking fluid on the daisies — see page 28.

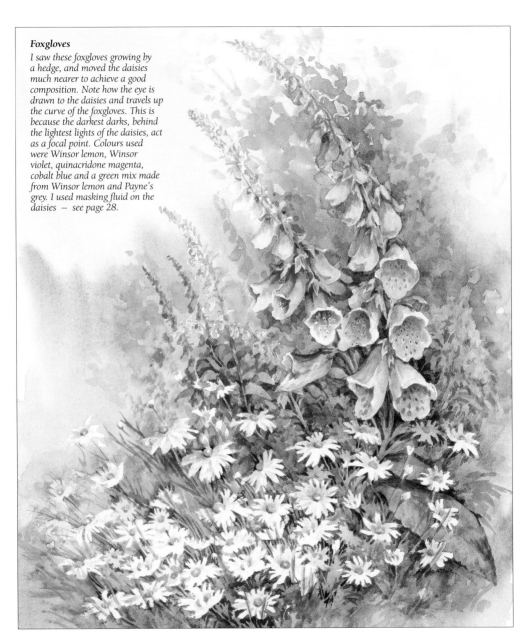

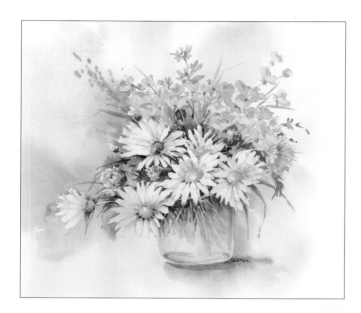

In a container
Flowers in a jam jar

I occasionally paint flowers in a container, but I am always far more interested in the flowers. I make sure they always take centre stage and keep the container very simple. For this picture, I used Winsor lemon, quinacridone gold, quinacridone magenta, Winsor violet, cobalt blue, and a green mix made from Winsor lemon and Payne's grey.

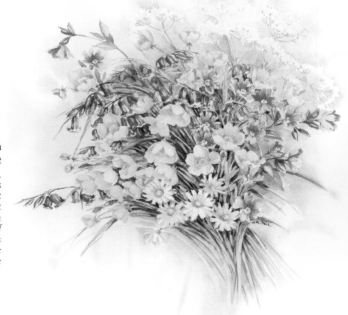

Hand-held bunch
Wild flower bouquet

To paint the flowers in a bouquet, you must remember that all the stems should come together to suggest that they are held in your hand. Notice that the cow parsley at the back has been painted in negative, using 'sky holes' of background colour to show the shapes between the stems and the almost-white flowers. The colours used were the same as in the painting above.

14

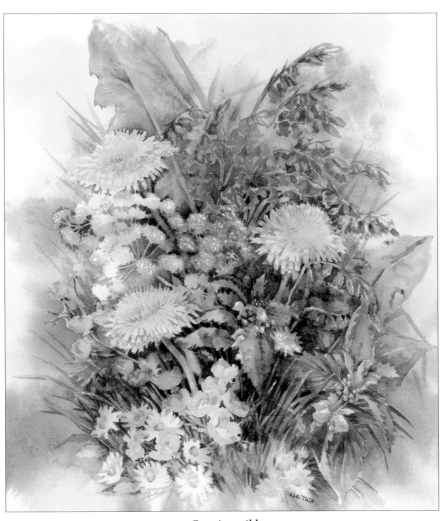

Growing wild
In the Hedgerow

*I just managed to rescue this painting after doing something that is all too easy —
putting too many darks in the initial background wash. The result was larger areas of
deep tones than I wanted, and I had to go in very dark with my small contrasts. I also
did something I rarely do: scratched out one or two highlights with the point of a
small knife. This must be done very carefully, or you end up with a hole in the paper.
Another option is to use white gouache, but I avoid this as it can look clumsy.*

Sketching

Although I love colour, I sometimes like to draw, and enjoy the exercise of a purely tonal painting. I also like to use a pen and wash technique, drawing first in a sepia pen, which is not as harsh as black, then adding a little colour wash. I find that different subjects dictate variations on this theme, especially if you have very sculptured flowers such as foxgloves, bluebells or harebells.

Sometimes, when you have been struggling with the complexities of watercolour, it is restful to try something different. Making a little sketch on a piece of scrap paper before you embark on a watercolour painting can also help you to understand tonal values. In my classes, we often divide the paper in two and draw the subject with a water soluble pen on one half, then paint in watercolour on the other half, using the brush straight on the paper – no pencil outlines. When painting an individual flower, take one petal or section at a time. Many students try to go round all the petals at once. You need to study the shape of each petal before you begin, and I am sure you will find it easier to paint each petal separately. Use the whole brush, not just the point.

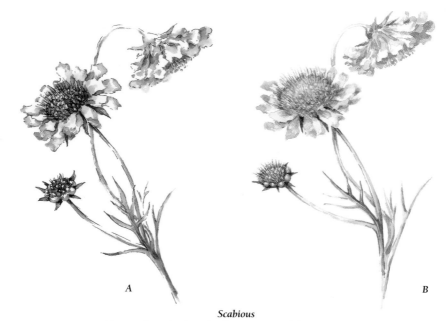

A *B*

Scabious

*The same flower has been first drawn in water soluble pen (A), which
helps to identify the light and dark tones before going on to use colour.
Then, in a separate study, it has been painted in watercolour (B).*

Water soluble pen

These pens are inexpensive and are very satisfying to use. Begin by
drawing the flower very lightly, using broken lines occasionally to
prevent it becoming too heavy. Take a small brush, No.1 or No.2, and
dip it in water. Roll it on a piece of rag to remove any excess water and
follow the drawing on the shadow side. You can then use the shadow
as you would if you were working in watercolour. Gauging the amount
of water you need will take practice.

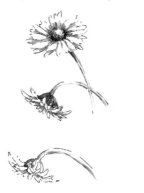

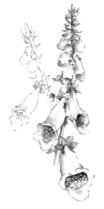

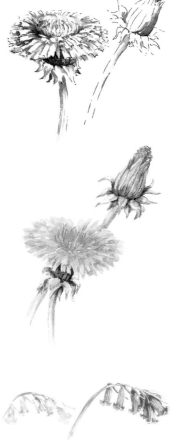

Watercolour

Keep the tones very pale to begin with. Draw with your brush, using
a No.6. Allow your work to dry, then make a stronger mix of the same
colours and use it to add details and contrast. This is where you can
adjust any shapes that may not have worked out in the paler wash.
I prefer to use a No.1 or No.2 brush for these smaller flowers.

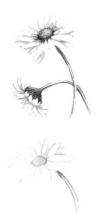

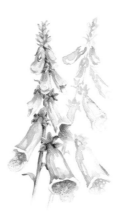

Leaves

Leaves are often neglected, which is a pity as they are beautiful in their own right. It must be remembered, though, that they should enhance rather than take attention away from the flower.

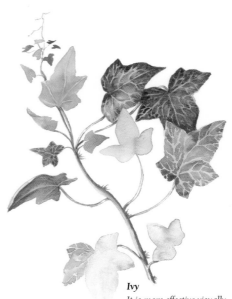

Ivy

It is more effective visually not to take every leaf to the same degree of finish.

Foxgloves

Buttercup

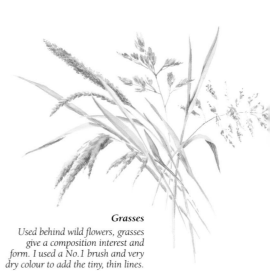

Grasses

Used behind wild flowers, grasses give a composition interest and form. I used a No.1 brush and very dry colour to add the tiny, thin lines.

Clover

Primroses and dandelions

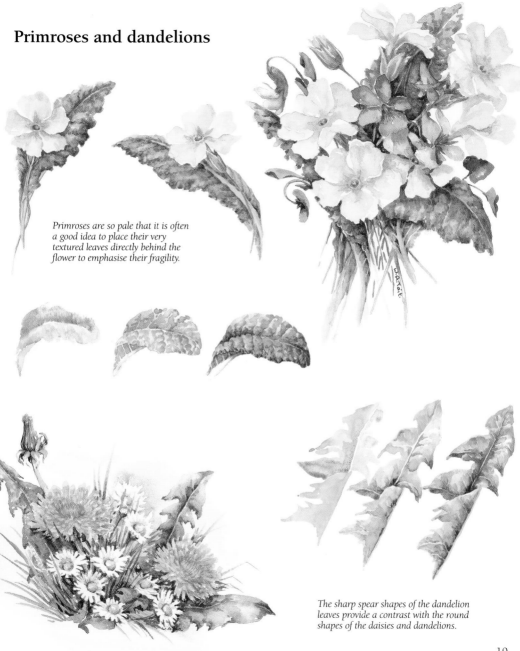

Primroses are so pale that it is often a good idea to place their very textured leaves directly behind the flower to emphasise their fragility.

The sharp spear shapes of the dandelion leaves provide a contrast with the round shapes of the daisies and dandelions.

19

Honeysuckle spray

This is a simple study, painted directly on to the paper. I have added a little background colour at the end, but you could leave this out if you wish. I do not think a tonal sketch is necessary for such a simple subject. Do, however, spend time studying the subject well before you begin. Note how the crown shape of the flowers radiates from the centre, the way each petal opens to show the inner gold, and the way the stems curve. Note that the leaves fold around the stem.

Remember that you are trying to achieve an impression, rather than a slavish copy, of your flowers, so you can use 'artistic licence' to adjust the finer points. Take the flowers out of the jar, look at them from different angles and paint the view of each that you like the best.

> ### You will need
>
> Watercolour paper
> 300gsm (140lb)
> Brush: No. 6 round
> Watercolour paints:
> Winsor lemon; brown
> madder; ultramarine;
> magenta; cobalt blue;
> indigo; quinacridone
> gold; Winsor violet;
> permanent rose

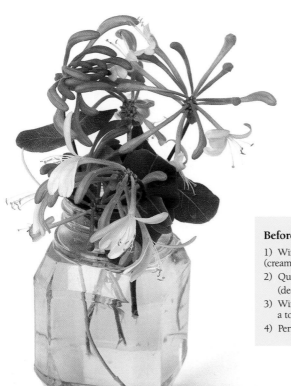

> ### Before you begin, mix the main washes:
>
> 1) Winsor lemon and permanent rose
> (creamy yellow)
> 2) Quinacridone gold with a touch of magenta
> (deeper yellow)
> 3) Winsor lemon and quinacridone gold with
> a touch of indigo (green)
> 4) Permanent rose (pale pink)

The flowers on which I based my painting.

1. Using a No.6 brush and the pale creamy yellow wash, put in a few marks to locate the shape of the flower. Change to the permanent rose wash and put in the petals, remembering that each petal should radiate from the crown of the flower. Rinse your brush and soften the effect using plain water.

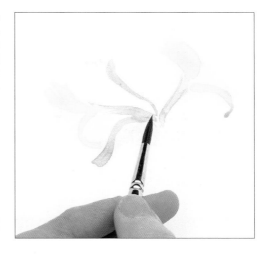

Note

Always begin with pale tones, adding darker ones when you have established the lights.

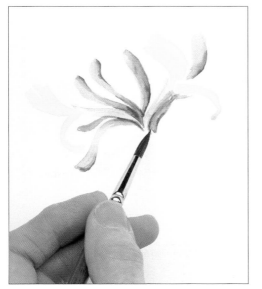

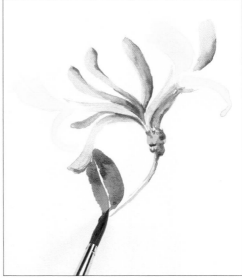

2. Make a stronger permanent rose mix and put in all the main flower buds, making sure they meet at the same point. Use a little magenta mixed with brown madder and a touch of Winsor violet for the shadow side, noting that the light is from the left.

3. With pale green made from Winsor lemon, quinacridone gold and a touch of indigo, put in the base of the flower. Add the tones using a mix made with a deeper concentration of the same pigment. Put in the first leaf with the same colours.

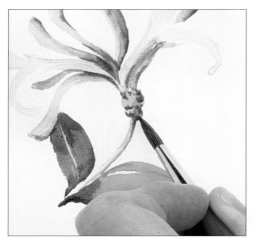 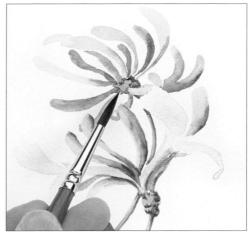

4. Put in two more leaves using the same colours, and adding a little ultramarine into the shadow side of both leaves. Reserve a fine line of white paper for the spine of the leaf, then tone it down by brushing a touch of water over it to take off the starkness. Add some very dark tone made from quinacridone gold and indigo to the base of the flower.

5. Add another flower, remembering that the petals of each bloom must radiate from the same central point. Use slightly darker tones of paint from the edge of the colour on your palette. The concentration of pigment is more intense where the flower passes behind the one in front. This helps to make it stand out. Add the stem in green.

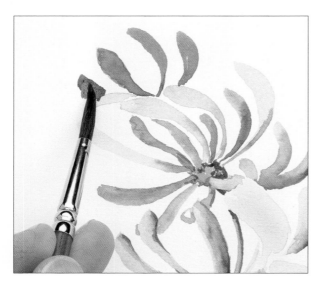

6. Increase the concentration of pigment in the pink mix and add a darker flower behind the last flower you painted. Each petal is done with one brush stroke, laying it on the paper and lifting it off.

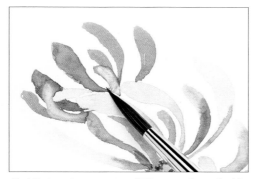

7. Mix in a tiny quantity of Winsor violet and add the darks on the shadow side of the flower.

8. Look at the balance of the whole picture. In this case, the composition needs some more detail on the right-hand side to balance it out.

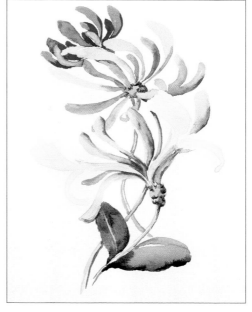

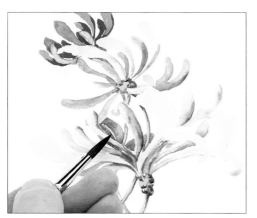

9. Add more fullness to the main flower, and some more leaves with green mix.

10. Build up deeper tones across the whole painting, making sure your brush has a good point.

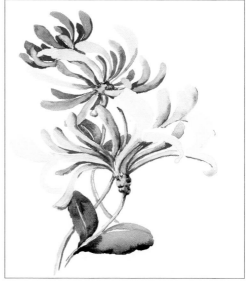

11. Add a small, dark bud at the bottom right to balance the composition. Put in the stalk, and a tiny leaf to stop the gap looking too big.

12. Work across the whole painting, adding magenta to the stems and to the shadow side to tie it all together.

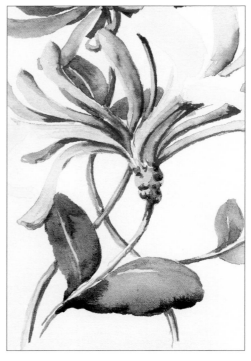

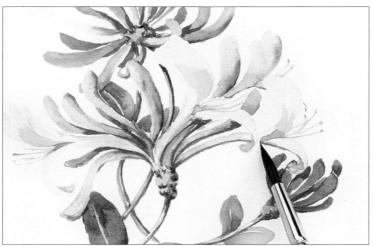

13. Add tiny details to the light flowers using quinacridone gold, then wash with clean water to soften the effect. Add tiny, very dry touches of violet in the shadows. Add cool shadows to the edges of the gold petals, where they are very thin, by touching the edges with a weak wash of cobalt blue.

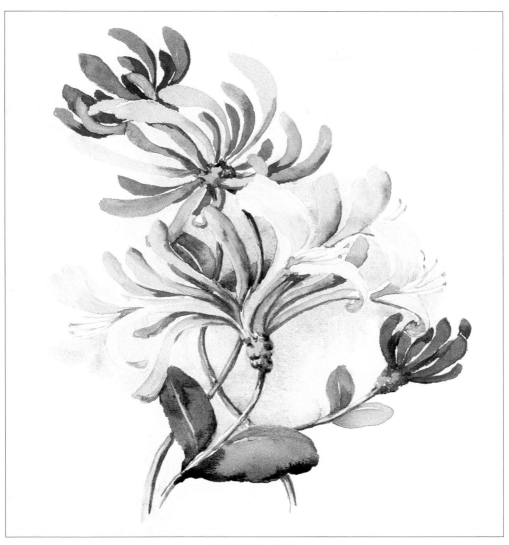

The finished painting

*The area between the flowers and leaves was wetted using a lot
of water, taking the water well away from the coloured area.
A little cobalt blue was dropped in and allowed to disperse.*

Painting backgrounds

The technique I use to create my backgrounds takes time and plenty of practice, but it can be great fun, and you can achieve some wonderful effects. At first, it is better to err on the side of soft colour than to make it too strong, as the colour can be strengthened at a later stage. Do not forget that your work will dry lighter. Experiment on the reverse of a discarded painting; if you are anything like me, you will have many. The colour should be dropped off the point of the brush: do not be tempted to paint at this stage.

The technique

Start by wetting the paper thoroughly right to the edges, leaving no dry areas. Wait a short time until the shine begins to go off the surface of the paper, then drop in the colours, using a No.12 brush. The colours must be near enough to each other to fuse or run together. Tip the paper in different directions to make this happen, but guide the colour away from your main point of interest. At the same time, remember to leave light areas which will be used for highlights.

Note

- *If too much colour gathers at the main point of interest, it can be lifted out or blotted away, but it is best to try to avoid this.*

- *If the colour runs too much, you are using too much water.*

- *If the colour does not run enough, add a little more water to the colour in your palette, not to the paper.*

Sample background
I left white spaces for the roses I planned to paint on this background. I dropped in blue (cobalt blue deep with a touch of Winsor violet) next to the yellow (Winsor lemon and quinacridone gold) so that it would merge slightly. Winsor violet was dropped in last, again right next to the other colours, to indicate the position of the background shadow.

Finishing the background

When you have completed your flowers, return to the background, which by now will have dried and may look very pale. You can drop in deeper colour behind the flowers immediately if you feel that the background is not strong enough, but remember to wet the paper right to the edge, then drop the colours into a small area only. Work on a small section at a time and allow your work to dry before moving on to complete the next section. Clear water can be applied to the paint without risk of the colour lifting, as long as it is allowed to dry between applications. Do not 'worry' at the paint while it is still wet: therein lies disaster!

Always cover a far larger area than you feel is necessary with water, and do not let the paint flow as far as the edge of the dampened area. Paint flow can be controlled quite easily by tipping your surface towards the flower to deepen the intensity of colour in the area behind it.

Try dropping in one colour, say blue, and after tipping it add a slightly stronger mix of another colour, say violet, and allow them to mingle. This can also be done effectively with a green mix. To avoid watermarks, remember that each time you put paint on, it must be a little thicker than the time before.

Wild roses

This example below was painted on a background very similar to the example on the facing page. The flowers were painted where I left spaces. When I had painted the leaves and the buds, I reinstated small darks behind them. I dropped in a blue sky shape between the 'negative' white shapes, which suggest more flowers.

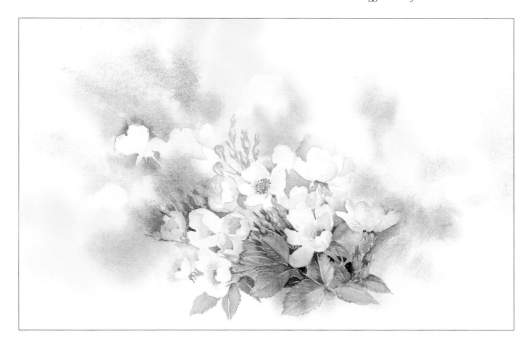

Using masking fluid

For the example below, I applied masking fluid in 'daisy' shapes, let it dry, then dropped in the background colours. Wet the paper right over the masking fluid and follow the instructions for backgrounds on page 26. When everything is absolutely dry, rub off the masking fluid gently with your finger. The negative shapes can then be painted between the grasses, and a little shadow added to the daisies using a pale wash of cobalt blue with a little green mix (Winsor lemon and indigo) added. Add the centres of the daisies using quinacridone gold and put in the shadows with the same blue and green mix.

In the painting below, I have taken some daisies to a finished state by putting in the darks behind them, and left some to show the stages of light, medium and dark tones. Note that the darker the tone, the smaller the area painted.

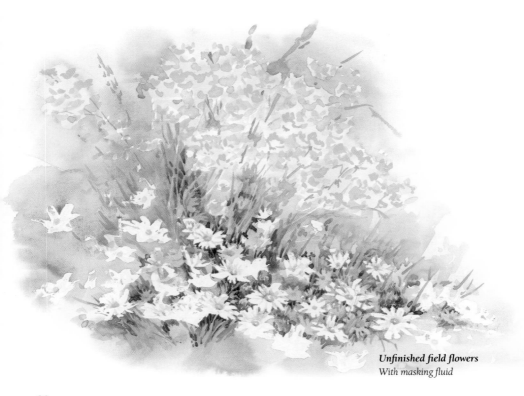

Unfinished field flowers
With masking fluid

Negative painting

There is a theory that white flowers are difficult to paint. This is not true at all: white flowers take very little painting. All the painting goes on behind them and around them: lots of negative painting and very delicate shadows on the flowers themselves.

I have used the same background technique for this painting as for the one opposite, but leaving 'highlight spaces' for the lightest flowers. This gives a softer effect. Remember that you should paint negative darks *behind* the flowers rather than painting the actual flowers. After painting the clover and the buttercups, go back into the pale flowers with a little shadow, and put in the centres.

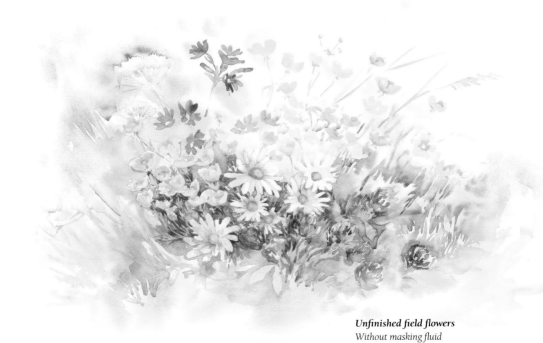

Unfinished field flowers
Without masking fluid

Negative flowers

With masking fluid

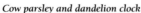
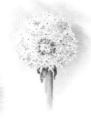

Cow parsley and dandelion clock

Apply masking fluid to the flower heads, using little star shapes for the dandelion clock.

Remove the masking fluid and paint the details on the shadow side of the flowers. Darken the shadow side of the stem.

Without masking fluid

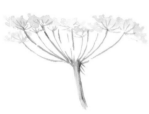

Cow parsley

Paint the positive shapes of the stems and under the flower heads directly on to the paper. Wet a large area round the flower, avoiding the flower heads.

Paint between the stems with the background colour, leaving white highlights on the light side. Let it dry, then paint details on the shadow side.

Dandelion clock

Paint the shadow side with a mix of pale green/blue. Let it dry and add details with star shapes, adding stronger colour on the shadow side. Wet a large area round this, leaving white highlights all round the clock, and while the paper is wet drop in background colour. Tip the paper to move the colour about.

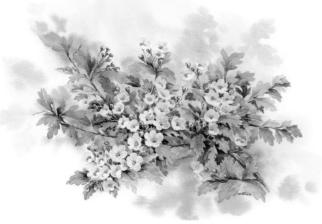

Hawthorn

This study shows negative flowers against dark background leaves. The strongest contrasts — the lightest lights and the darkest darks — are concentrated around the focal point.

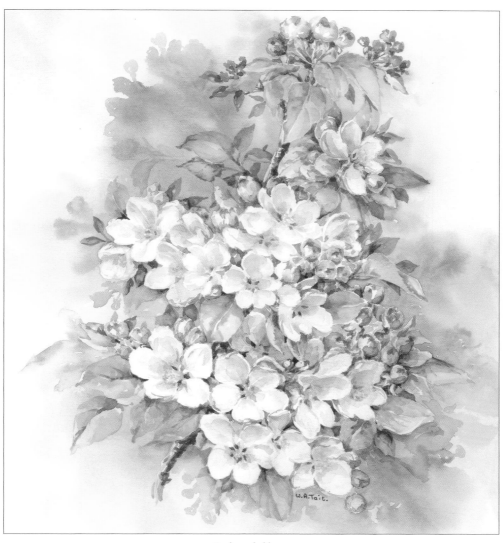

Crab apple blossom

I know where to find these small trees in my local fields, and I paint them in bloom almost every year. Again, the apple blossom depends heavily on the tiny darks between the leaves to show up the white and pink blossoms, which are painted in negative. If you paint the leaves a mid-toned green you can add a darker green made from indigo and quinacridone gold to really sharpen up the image in the shadows.

31

Wild roses

The second project introduces a coloured background which makes a picture of the subject instead of just a study. I drew the roses with a water soluble pen on a separate piece of paper before I began, to familiarise myself with the different tones. I began the painting on a fresh piece of paper, and started by dropping in the background.

You will need

Watercolour paper 300gsm (140lb)
Brushes: Nos.12 and 6 round
Large hake brush
Absorbent paper or rag
Watercolour paints: Winsor orange; quinacridone gold; permanent rose; cobalt blue; Winsor lemon; magenta; Winsor violet

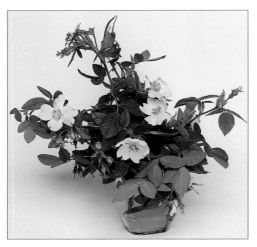

The bunch of wild roses I used. If you cannot find many roses, turn the jar and use the same flower from a different angle.

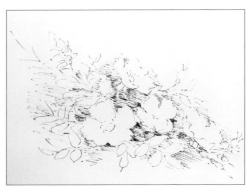

Rough sketch in water-soluble pen, for guidance only.

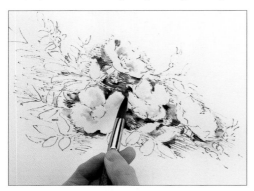

Make a sketch in water soluble pen and add water to intensify the tones. This is for use as a tonal plan, not for painting.

Before you begin, mix the main washes:

a) Quinacridone gold and Winsor lemon (yellow)
b) Permanent rose (pink)
c) Cobalt blue deep with a touch of Winsor violet (blue)
d) Winsor lemon, quinacridone gold and indigo (green)

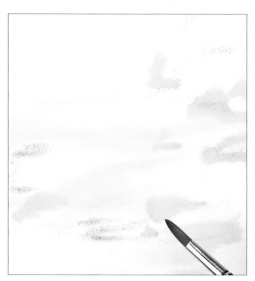

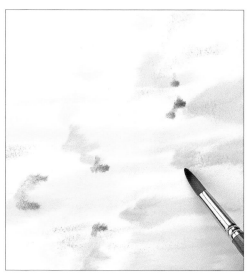

1. Wet your paper using a large hake brush and sweeping strokes. Change to a No.12 brush and immediately start dropping in background colours.

2. Tip and rotate your paper as you continue to add in the background colours, so they mingle and spread to form interesting shapes.

Note

If you are unsure about planning your background, refer to page 26 for more details of the technique.

3. If any colour has run into the reserved highlights for the main flowers, dab with absorbent paper or rag to remove it.

4. Change to a No.6 brush and put in the roses using a pale mix of permanent rose and Winsor orange. For a smooth result lay the whole brush, not just the point, on the paper. Where the tones are deeper, increase the concentration of the pigment. Do not worry if you go over some of the green or blue areas. Note how the dark blue splodge in my painting is used for the darks behind the flowers.

5. Make a fairly strong wash of quinacridone gold and put in the centres of the flowers. Add a spot of green mix wet-in-wet for the centres and shadows.

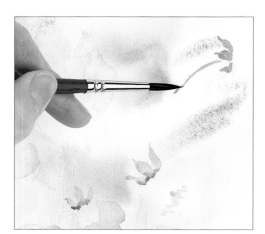

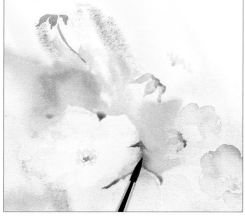

6. Paint in the sepals using the green wash, then add extra pigment in the mix to make a medium toned green and add the shadows, wet-in-wet. Paint in the stems, keeping them fairly short at this stage in case you want to add more flowers later.

7. Re-wet the areas round some of the flowers and drop in tones of the medium green for the foliage. Mix a slightly deeper green with Winsor lemon, indigo and quinacridone gold and use this to drop in slightly darker tones right next to the flowers.

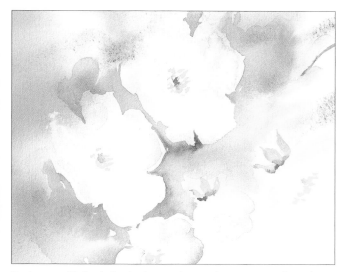

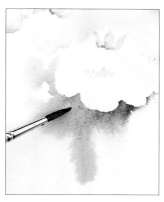

8. As you add the darker background tones, leave a narrow line of white paper on the edge of each petal where it catches the light. This will help the flowers to 'stand out' from the paper.

9. Damp the painting round the outside flowers, taking the water right to the edge of the paper. Add in cobalt blue with a touch of violet and let it run, then add a touch of green mix and let it run, tipping and turning your work to achieve the desired effect.

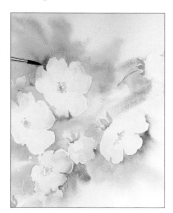

10. Work round your painting, concentrating on small areas and improving on your 'drawing' as you go. Put in the shadows behind the petals with a blue mix made from cobalt blue and violet.

11. Add some of the flower buds using a pale green mix of Winsor lemon and indigo. Strengthen the concentration of pigment in the mix and put in the shadows, remembering where the light is coming from.

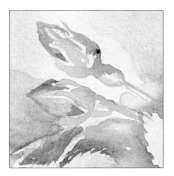

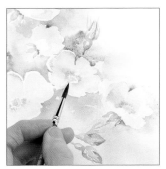

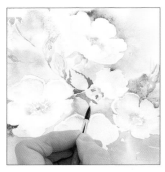

12. Mix a deeper pink with a touch of Winsor orange and add buds where necessary, leaving a very fine white line round the green parts of the bud. Increase the pigment in the green mix and put in the shadows of the buds.

13. Add touches of pink on the shadow side, and re-define the stamens with gold. Use a mix of cobalt blue and Winsor violet to define the centres. Drop in a little green mix by the stamens, and let it bleed into the blue.

14. Make a deeper green from Winsor lemon, indigo and a touch of quinacridone gold. Use it for negative painting behind the leaves, studying the flowers to see how the leaves grow. Soften off some outside edges with water.

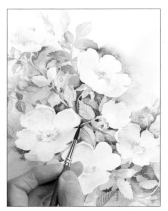

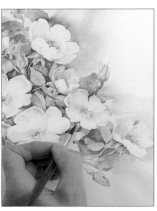

15. Add the leaf detail, painting the halves of each leaf separately and dropping in a little darker colour on the shadowed side. Always mix in violet or blue to shadow green, never Payne's grey or indigo. Add the fine lines on the leaves.

16. Continue to build up detail, remembering that to give depth to your painting some leaves should be seen only partially and in shadow. These will not show any detailed fine lines.

17. Work over the painting, adding tiny touches, sharpening up details and softening edges with a little water where necessary. Stop before you begin to 'fiddle'.

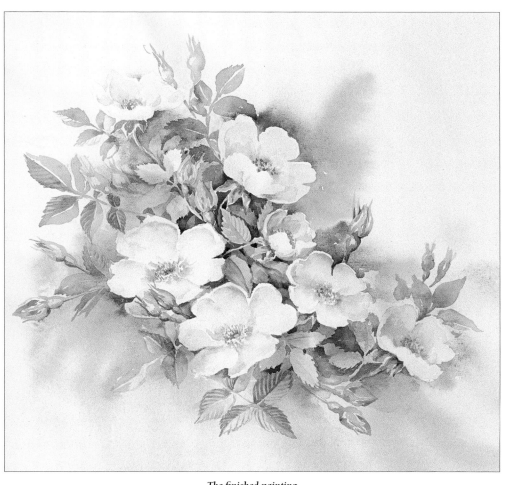

The finished painting

*When working over the painting, always bear in
mind that the darkest darks go behind the lightest
lights and vice versa. I have also added a couple of
buds in front of one of the flowers to make the
overall effect more natural.*

Wild flowers

The final project is a bunch of wild flowers in my favourite pinks, violets and blues. Daisies give a pale focal point, and leaves and grasses provide the contrasts. It is quite loosely painted, as I feel it suits the wild subject.

I sometimes sketch out the tones and shapes of the composition, as seen in the drawing (below right). Do not forget that this drawing is for reference only and is not to be used in the painting.

You will need

300gsm (140lb) watercolour paper
Large hake brush
Brushes: Nos. 12 and 6
Watercolour paint: cadmium lemon; quinacridone gold; Winsor violet; permanent rose; indigo; cobalt blue; magenta; brown madder

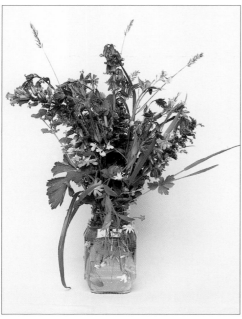

The flowers I used

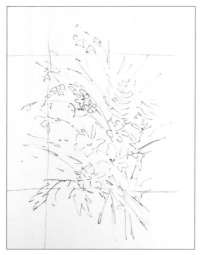

My outline sketch

Before you begin, mix the main washes:

1) Winsor lemon and quinacridone gold (yellow)
2) Winsor lemon and indigo (green)
3) Winsor lemon/ indigo as above, but with more water (pale green)
4) Cobalt blue and Winsor violet (blue)
5) Permanent rose and magenta (pink)

1. Use a large hake brush to wet the whole of your paper. Mop the lower edge with absorbent paper so excess water does not seep up and spoil the washes.

2. With a No.12 brush, scoop up a good quantity of yellow wash mix and sweep it across the paper. Rinse the brush and drop in a sweep of blue mix.

3. Add some of the pink wash mix right next to the blue, and let the colours run down, then repeat the process with the pale green wash.

4. Hold the painting at a different angle, then add some more blue wash mix and let it run down. Tip the paper quickly so the colours do not run over each other; the desired effect is for them to merge slightly.

39

5. Build up the areas of paler and darker washes, letting the shades run and merge to produce a soft background.

6. Lay the painting flat. If any colour has run into an area you want to reserve, lift it out with a clean, dry brush or some soft tissue if you prefer. Leave to dry.

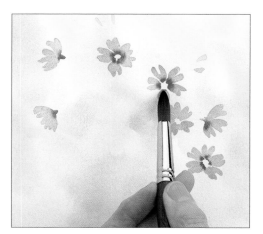

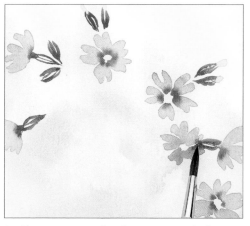

7. Change to a No.12 brush. Add more pigment to the pink mix and put in the campion petals. Deepen the pigment again and put in the centres wet-in-wet, letting them bleed into the petals. The background will be almost dry by now and you can begin the detail.

8. Change to a No.6 brush. Mix up a pinky-brown using brown madder and violet and put in the leaves and buds. Lift out any runs with a clean, dry brush.

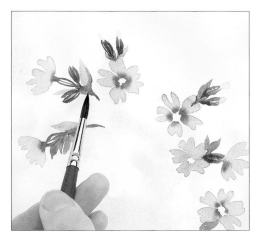

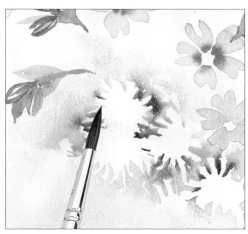

9. Add green mix to the leaves. Put in short lengths of stem, but do not take them too far as you may want to add another flower later. Darken the green with a little of the pinky-brown and add the shadows and darks, letting the darks run a little wet-in-wet.

10. Painting in negative, wet the area down to where the white flowers are to be, taking it behind the flower shapes. Drop in some blue round the flower shapes, then drop some green into the wet blue.

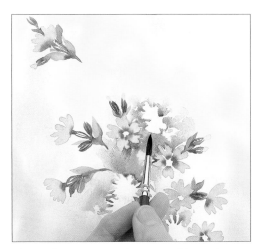

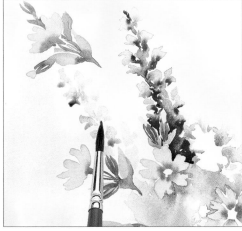

11. Do the same again, dropping in blue and green wherever you need contrast to show up a pale flower.

12. Paint the bugle flower on the right with a pale mix of cobalt blue and violet. Drop in the green stem, letting it bleed, then as that dries drop in the violet. Repeat for the second bugle flower.

13. Add a few more campions on the yellow area on the right of the painting, using exactly the same tones as for the ones put in earlier.

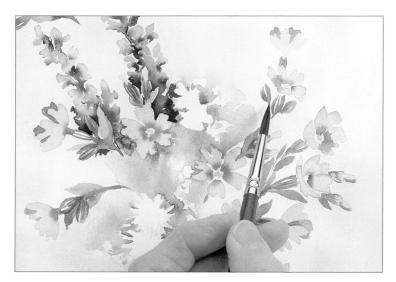

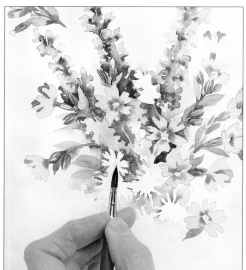

14. Painting in negative, continue dropping greens and blues in deeper tones behind the paler flowers. Ultramarine and violet make a good intense blue just behind the campions. Add the daisy centres in green.

15. Paint any flowers on the outer edges of the bunch, making sure that they are paler than the ones in the centre.

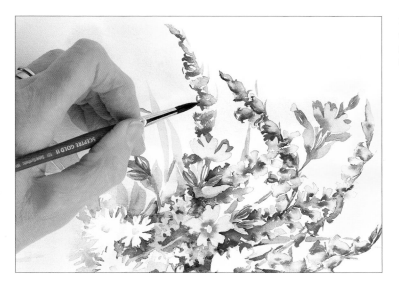

16. Wet the flowers with clean water and add darker tones to the shadow side.

17. Paint the leaves in two sections to show light and shade.

18. Mix darker green from quinacridone gold and indigo and use it to paint in negative behind some stems. Make another mix of cobalt blue and violet and do the same to suggest background.

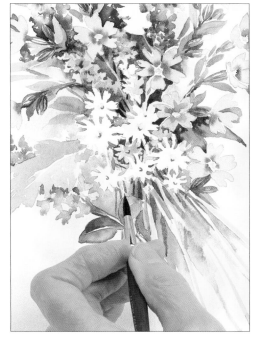

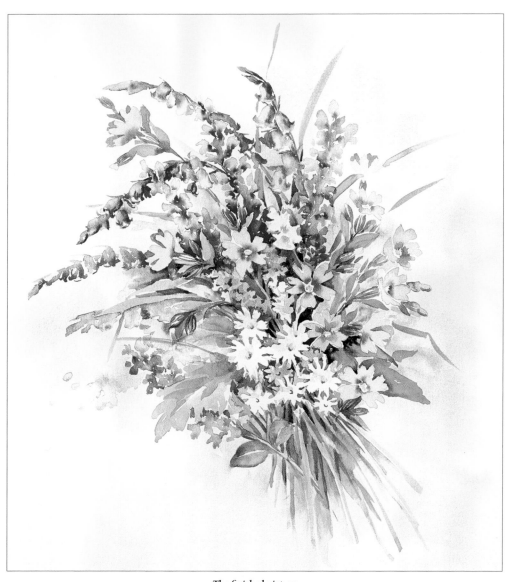

The finished picture
*As usual, I have placed the pale flowers low in the composition
so they have the darkest leaves for contrast.*

Poppies and daisies

*One of the potential
pitfalls with poppies is
to begin with too dark
a red. I usually begin
with a pale orange
or lemon, adding
magenta and more
orange to achieve the
colour. Note that the
really dark tones are
the areas of shadow or
where a petal crosses.
The highlights are left
with very thin washes,
especially towards the
edges of the petals.*

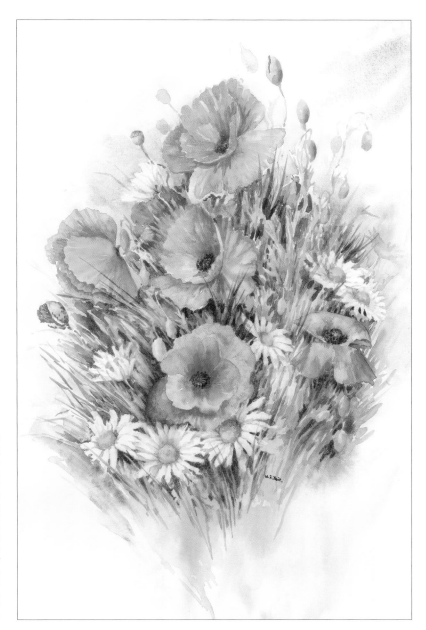

Conclusion

My best advice to anyone who wants to paint is: be true to yourself. By all means read the books and attend exhibitions and demonstrations, but regard what the 'experts' offer you as an addition to the way you want to paint, not as an example of the only way to paint.

Many painters who belong to clubs or classes become very disheartened by other people's comments, well-meaning or otherwise. But these can only be guidelines as to the way to do it. Never forget that you are part of an adventure into painting. Someone else's opinion is bound to be biased, and this affects their view of your work. Do not let it! Listen to advice, practise what other people tell you if it appeals to you, but do not let it reduce your confidence in your ability. Confidence is your most important asset. Remember that throughout the centuries artists have struggled, often against the tide of popular opinion, to win through in the end!

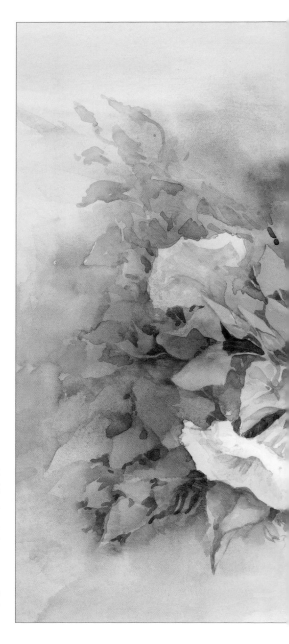

Bindweed

After painting in pale shades, I really enjoyed 'going to town' on strong contrasts. In the background I used lemon, gold, cobalt blue, violet and my green mix. For the strong darks, I used more violet, blue and brown madder. Note that the strongest darks (very small) are right next to the lights (quite large), giving me a focal point for my composition. I finished by glazing the whole painting with a lemon/gold mix, by mixing a big 'puddle' of very transparent colour and applying it in large, fast strokes with a hake brush. I lifted out the highlights quickly. This is a tricky procedure but if you are positive with your strokes and do not go over your work more than once, the colour underneath will not lift.

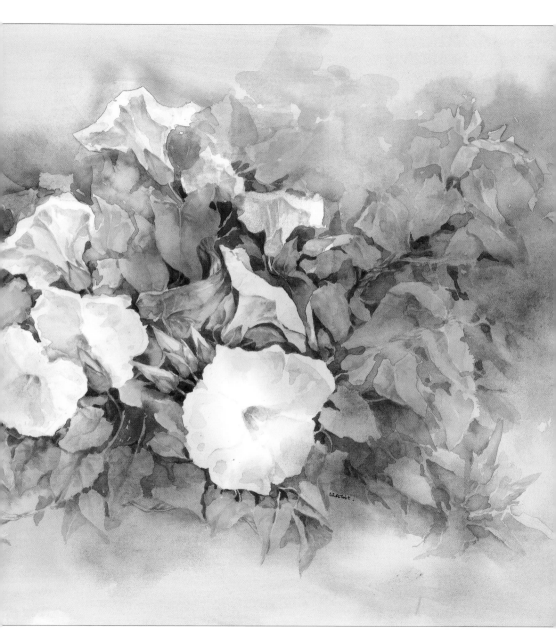

Index

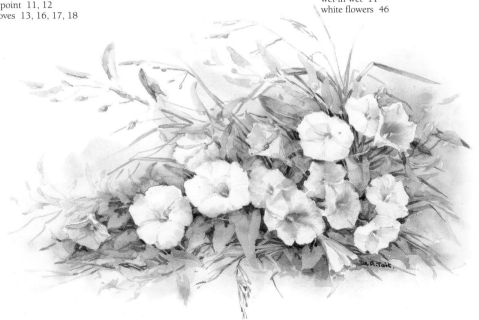